Nive Se Color!

AFRICA

COLORING BOOK

Check out the full line of Vive Le Color! coloring books at www.abramsnoterie.com

ISBN: 978-1-4197-2252-3

Copyright © 2014 Hachette Livre (Marabout)

English translation copyright © 2016 Abrams Noterie

(135), Katya Ulitina (49, 141), Vectorok (51), Yaviki (41, 101, 111), Yoko Design (3), Zelena (23, 35, 53, 65) Rudzko (89), Seamartini Graphics (67, 117, 131), Snapgalleria (73), Tashile (59, 85, 119), Tupun Gato Kurzakova (9, 97, 127, 129, 143), Malchev (43), MaryNo (63, 125), Dina Oris (103), Osov (29, 55), Maryna 33), Konyayeva (15, 45, 95, 105, 139), Anthony Krikorian (25, 81), Kudryashka (21, 37, 71, 115), Anna (37, 97), Green-Mermaid (109), Incomible (77, 133), Irmairma (7, 75), Svetlana Ivanova (17), Joat (27, 13), Boonkan Arun (107, 113), Vladimir Ceresnak (47, 83), Cupoftea (11, 39, 69, 79, 99, 137), Fresher Interior designs: Abeadev (19, 87, 93), Oksana Alekseeva (57), Annareichel (61, 121, 123), Bekulnis (5, Cover design: Vladimir Ceresnak Illustrations © Shutterstock

mechanical, electronic, photocopying, recording, or otherwise, without written permission from ьоок тау be reproduced, stored in a retrieval system, or transmitted in any form or by any means, Published in 2016 by Abrams Noterie, an imprint of ABRAMS. All rights reserved. No portion of this

the publisher.

E7591860L Printed and bound in China

address below. also be created to specification. For details, contact specialsales@abramsbooks.com or the for premiums and promotions as well as fundraising or educational use. Special editions can Abrams Noterie products are available at special discounts when purchased in quantity

715 West 18th Street

mmm.abramsbooks.com New York, NY 10011

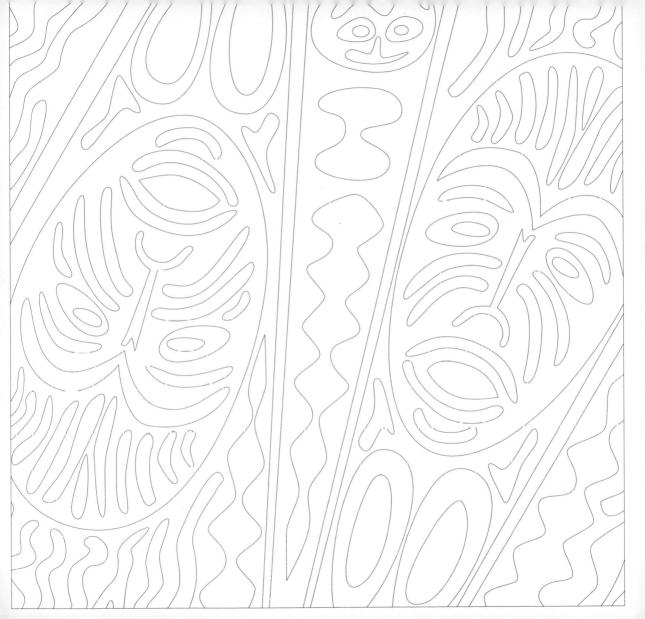

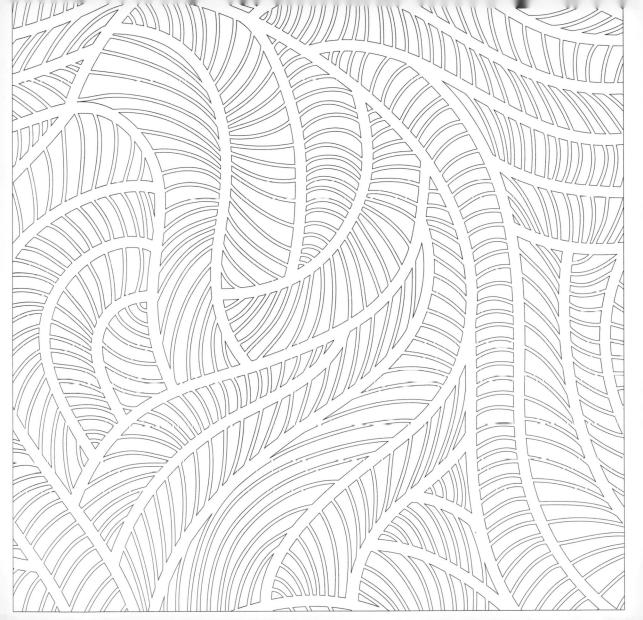

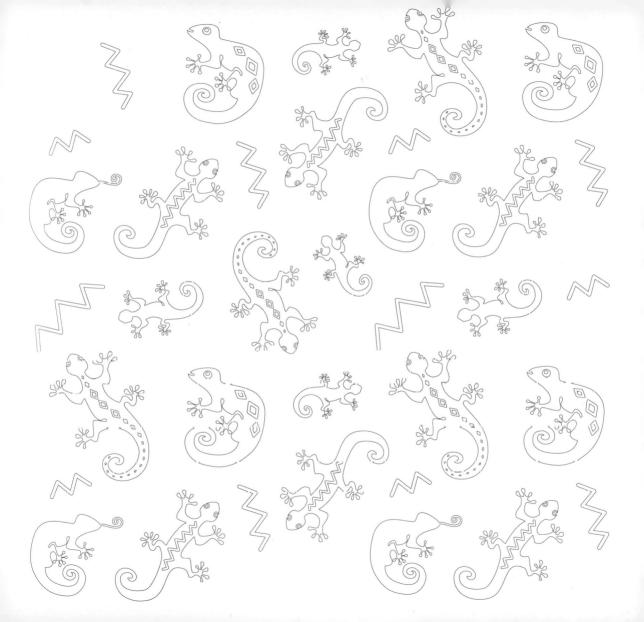

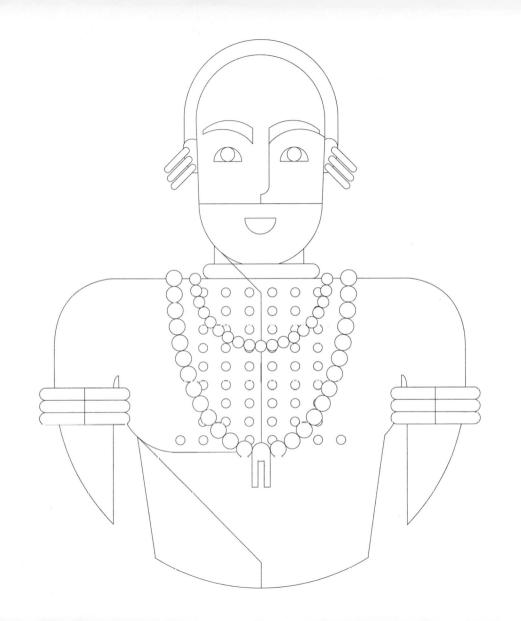

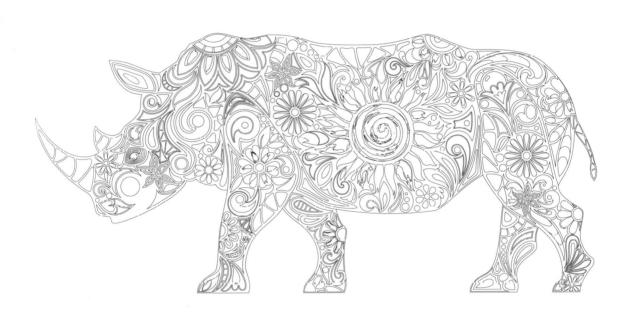

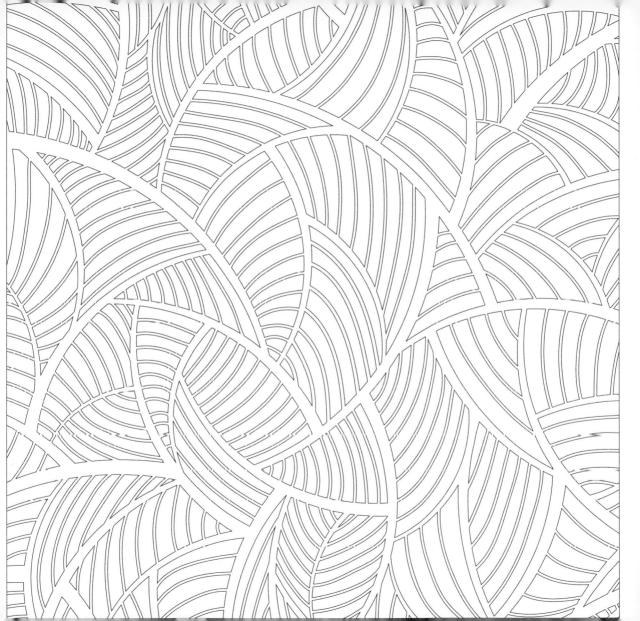

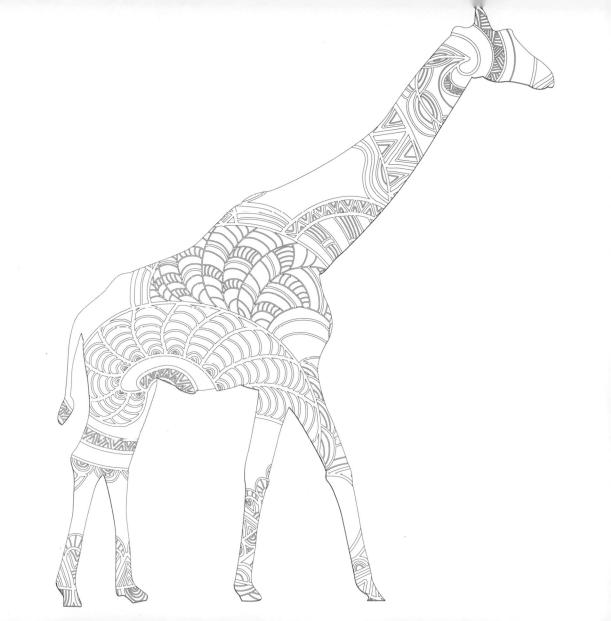

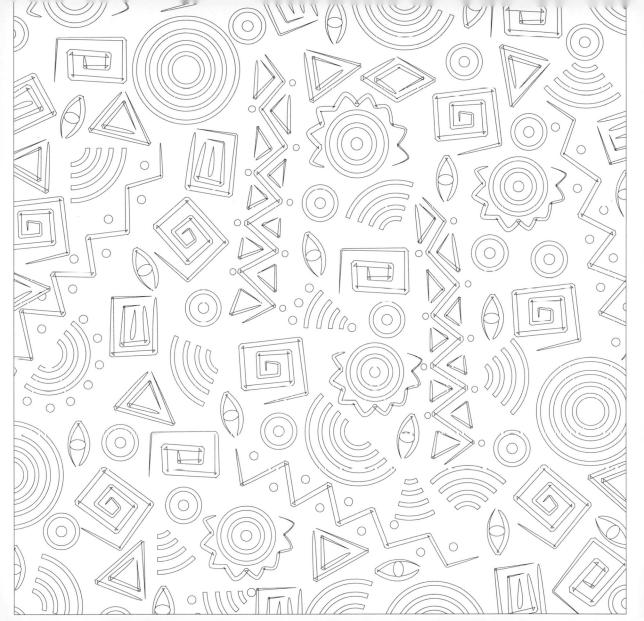

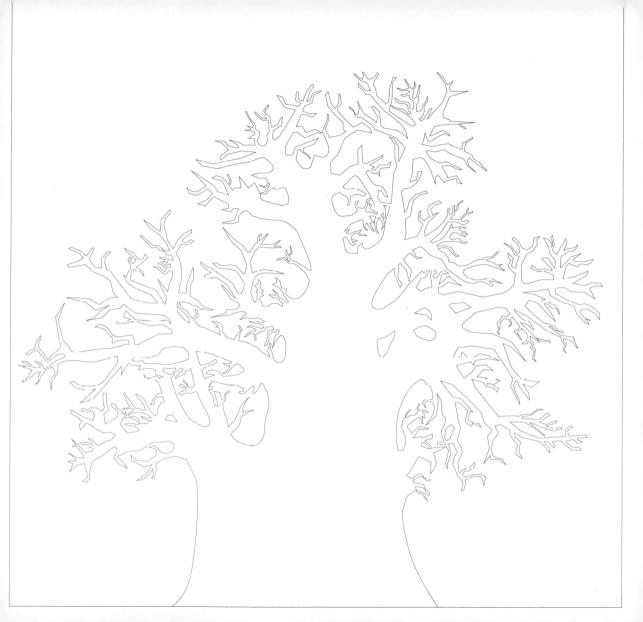

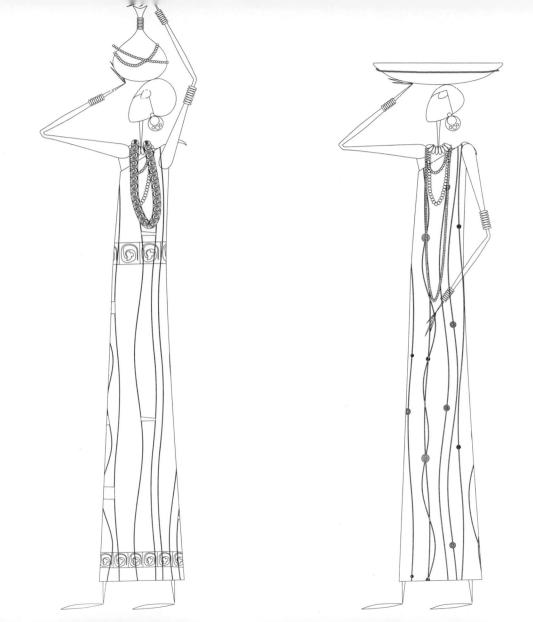

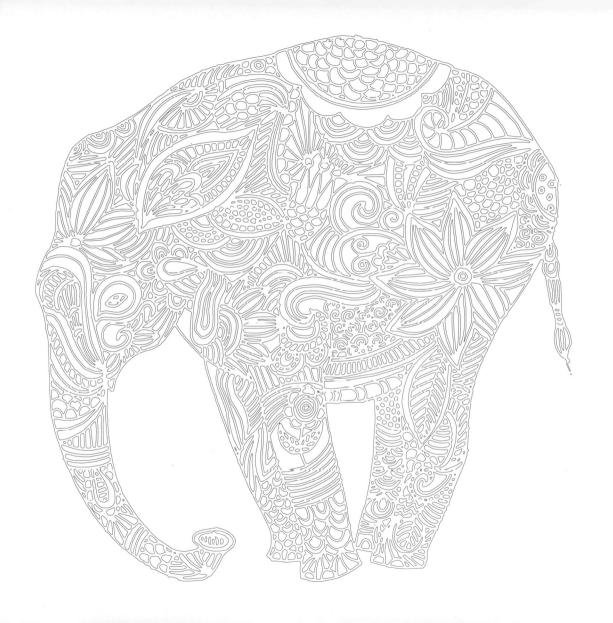

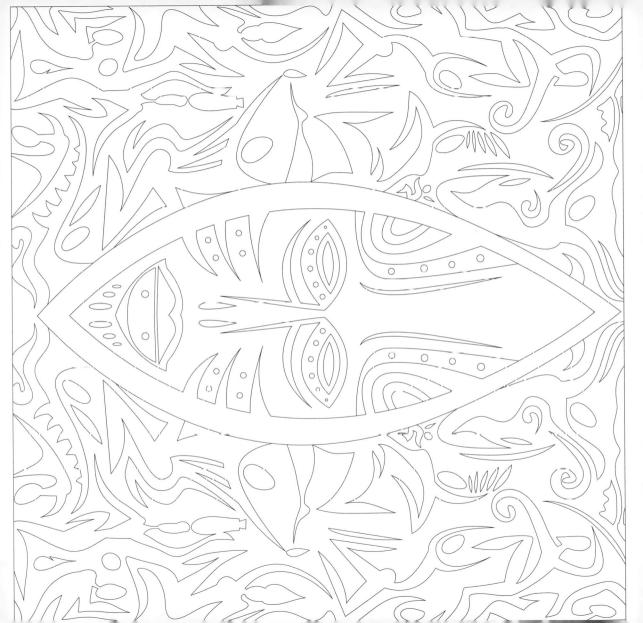

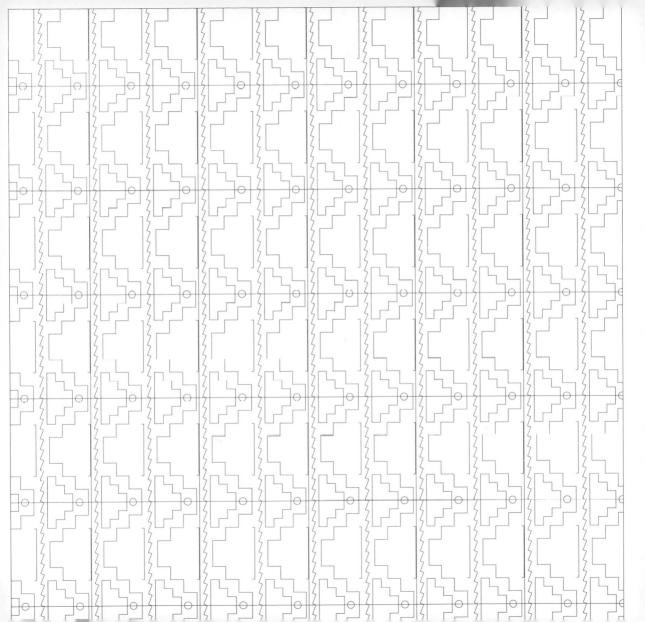

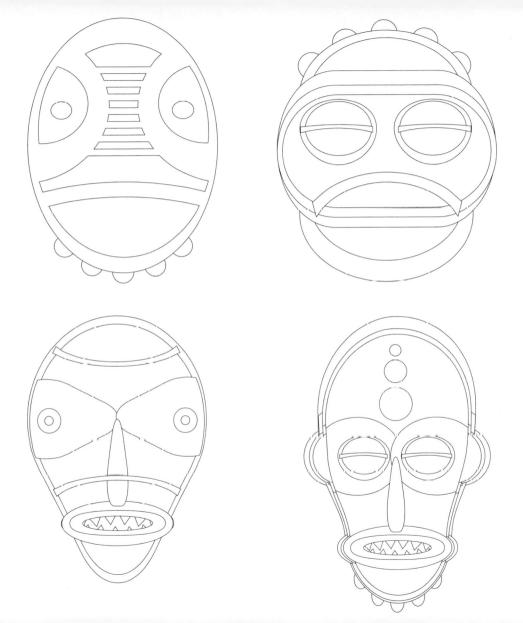

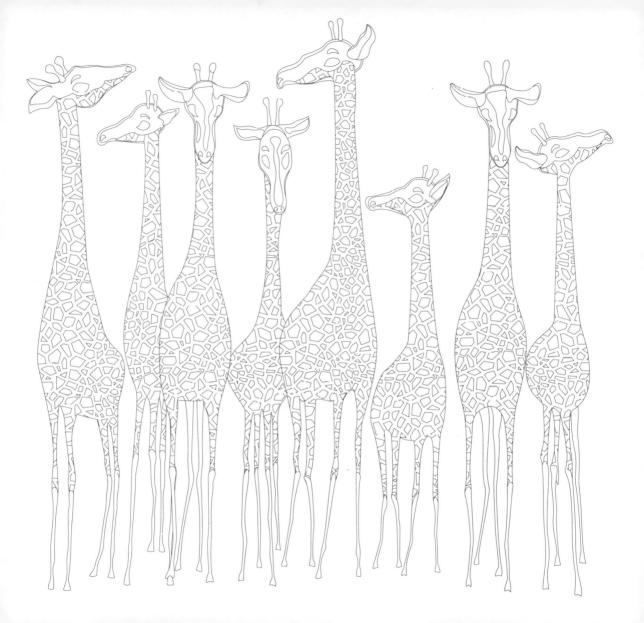

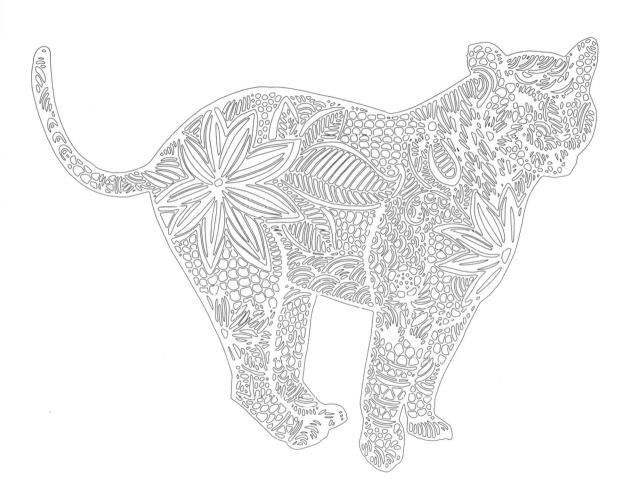

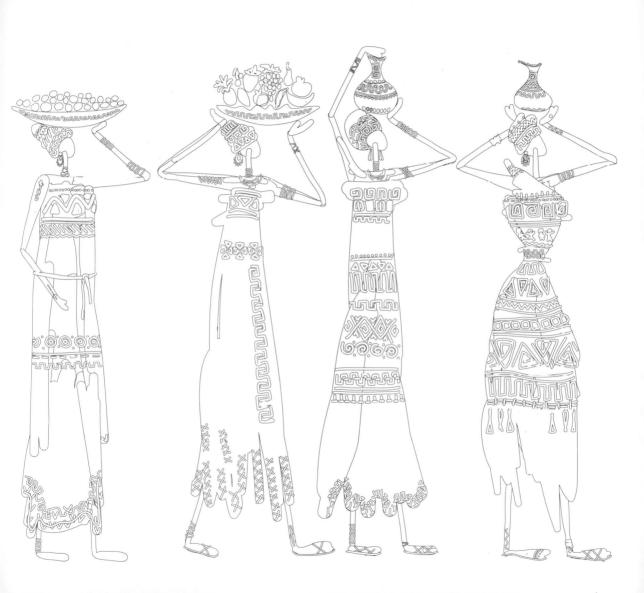

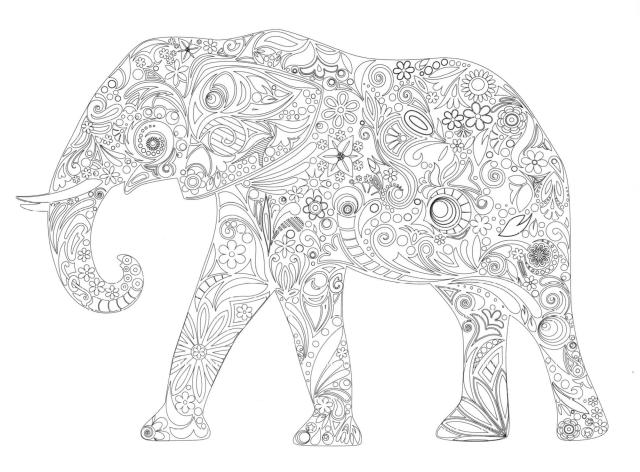

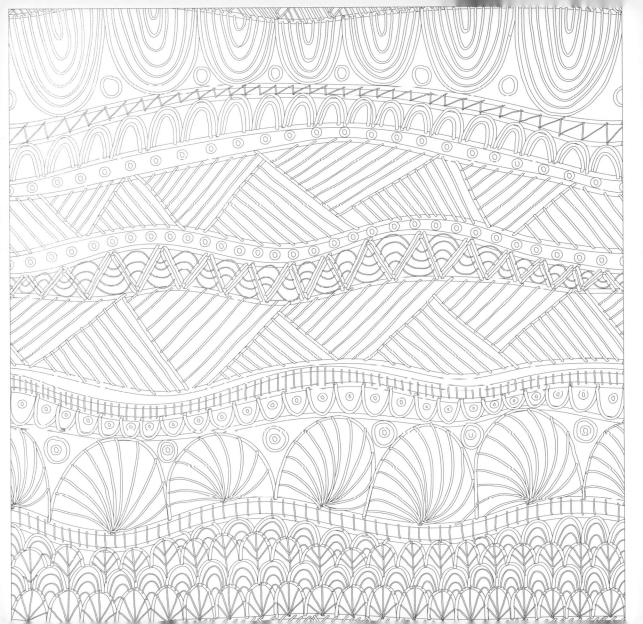

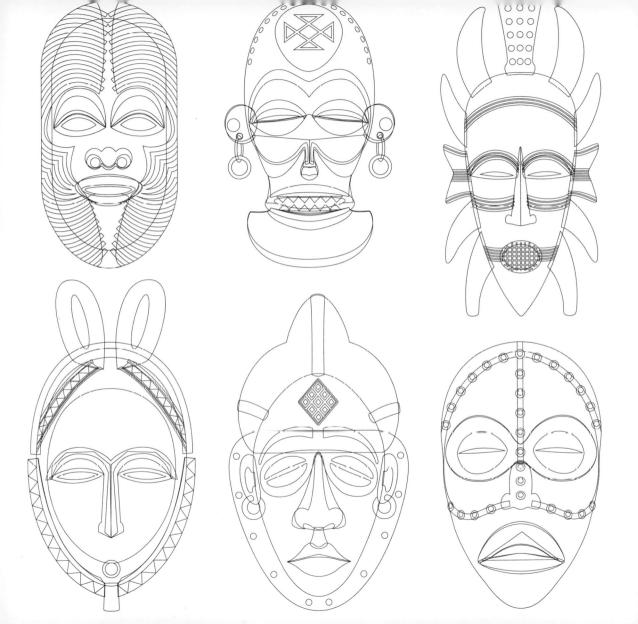

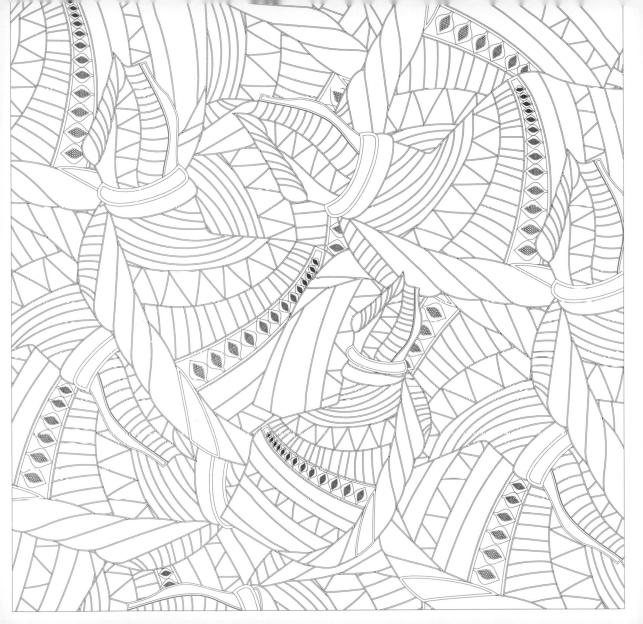

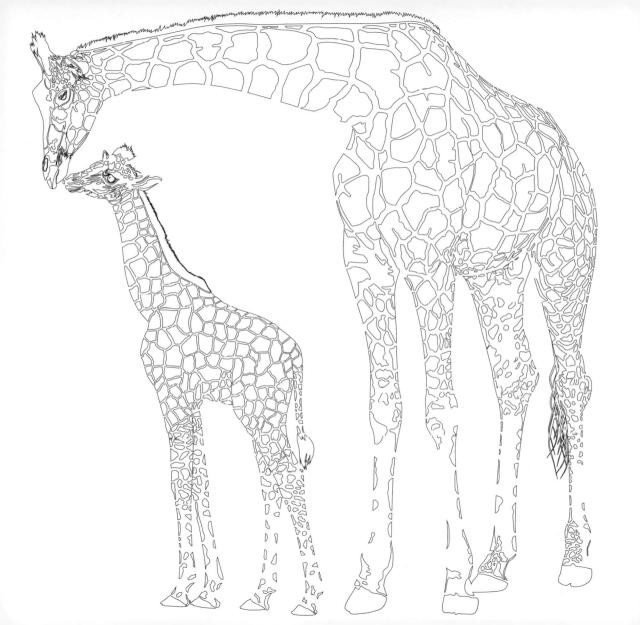

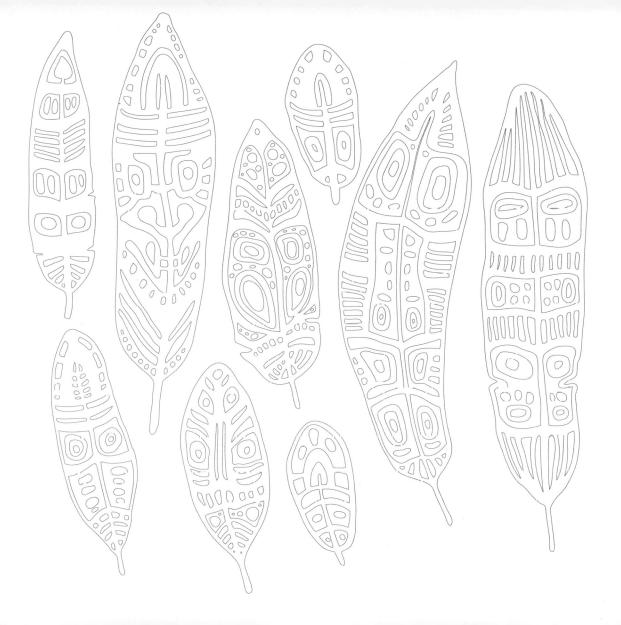

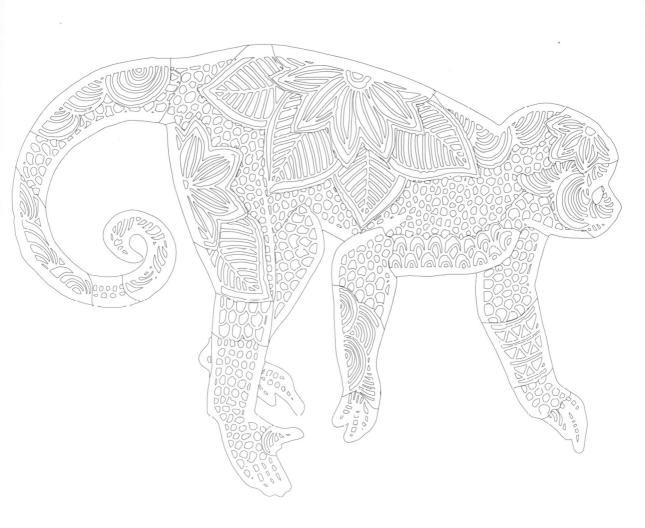

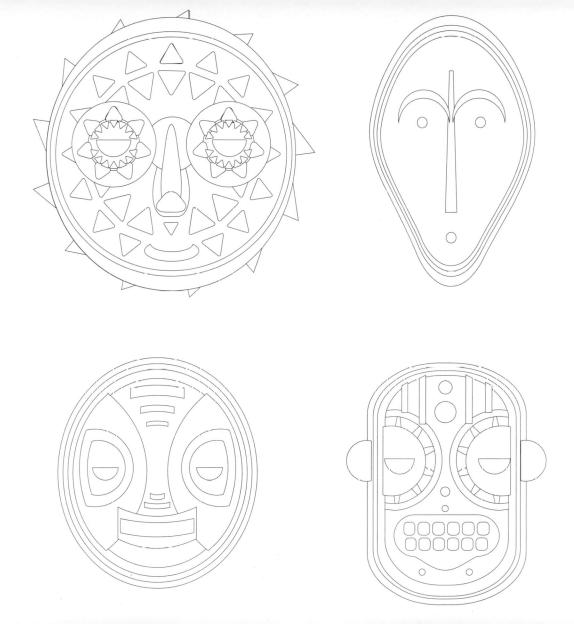

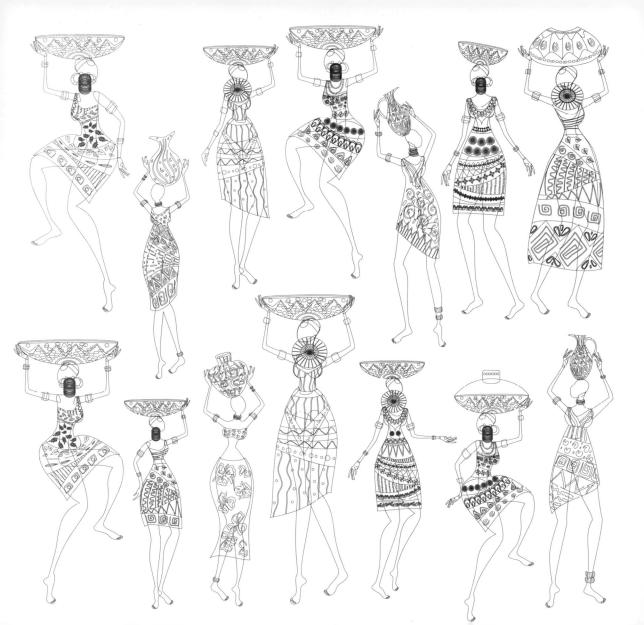

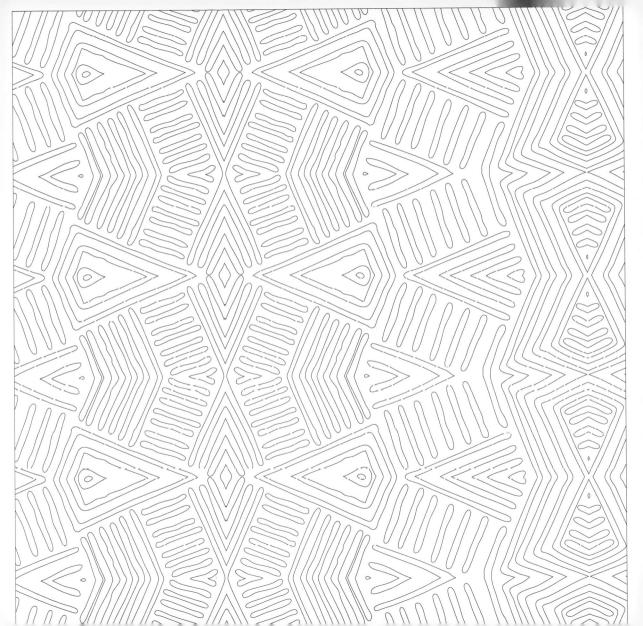

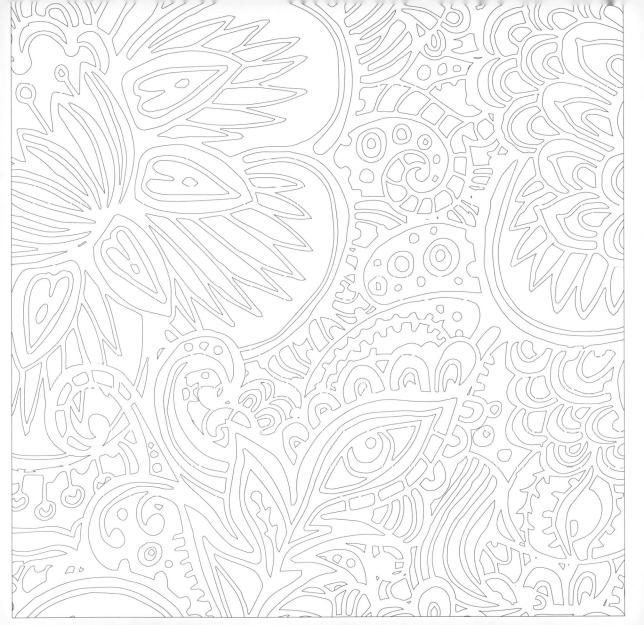

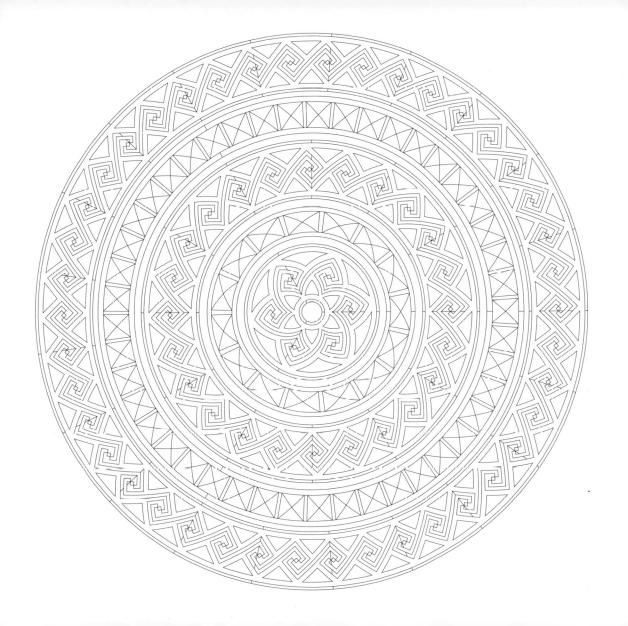

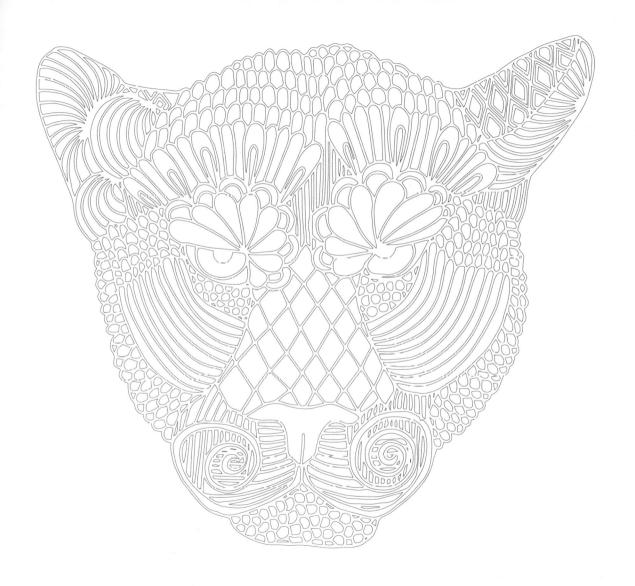

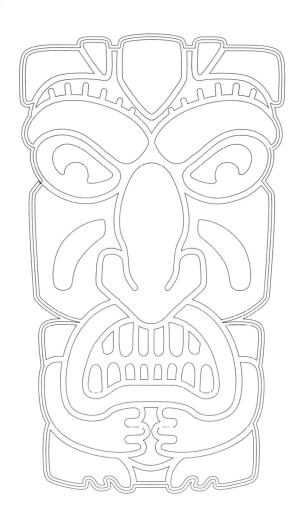

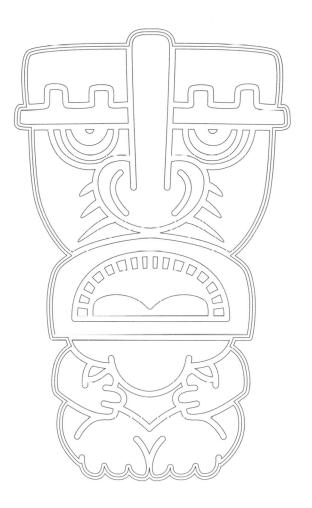

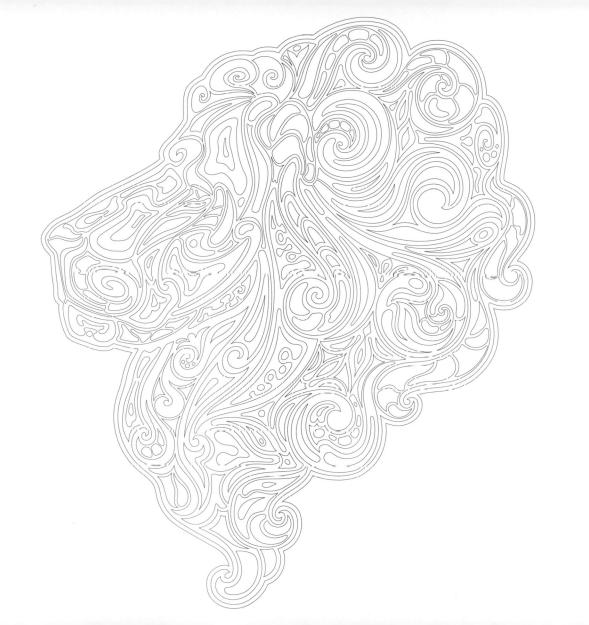

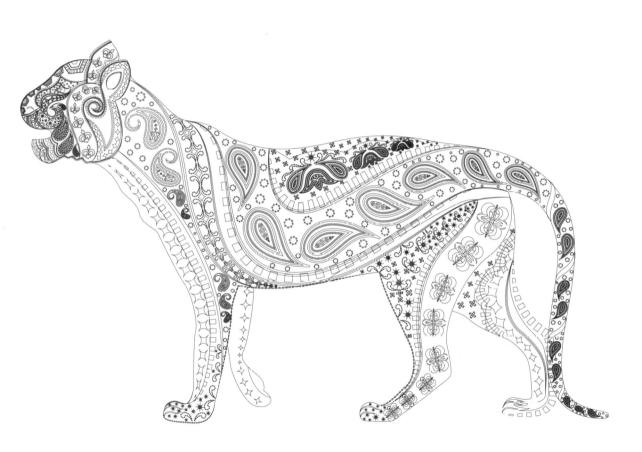

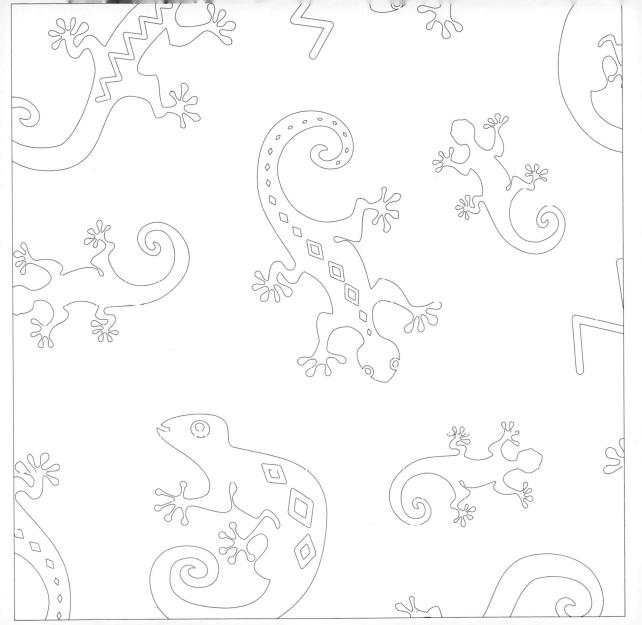

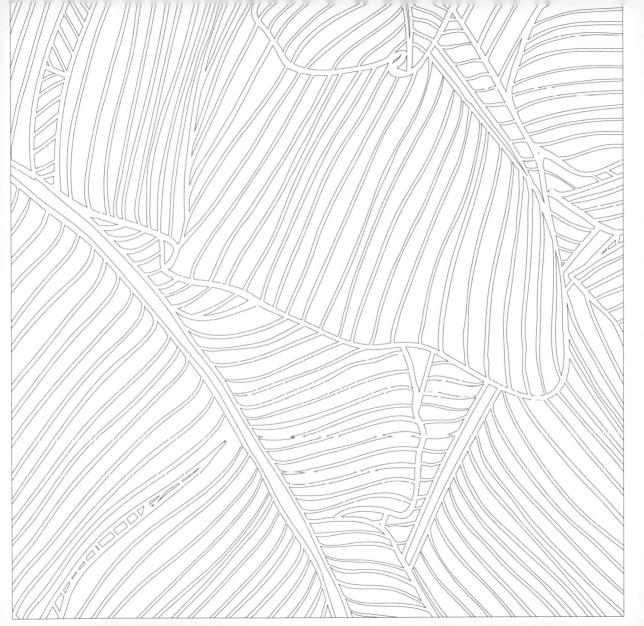

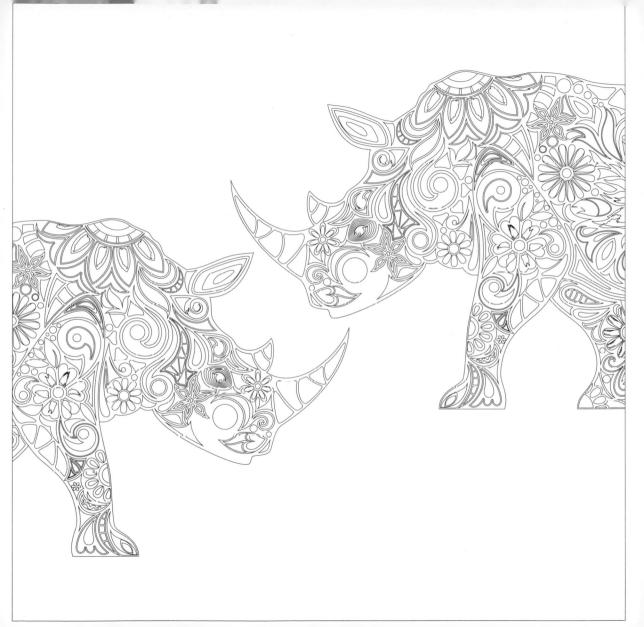

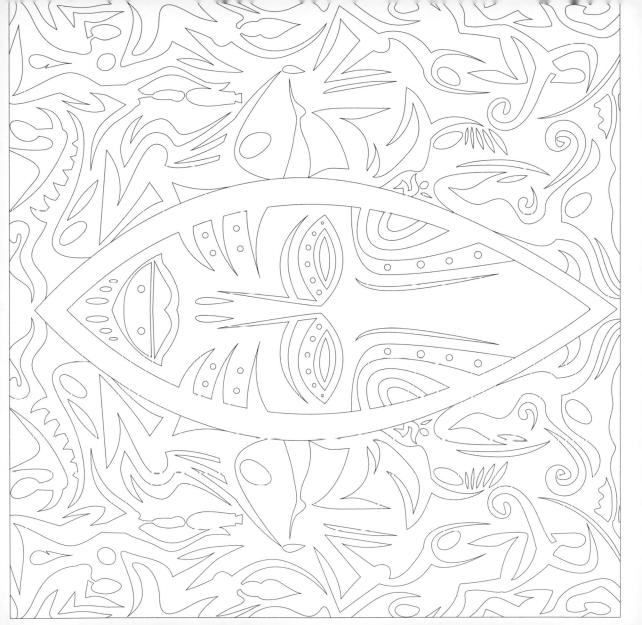

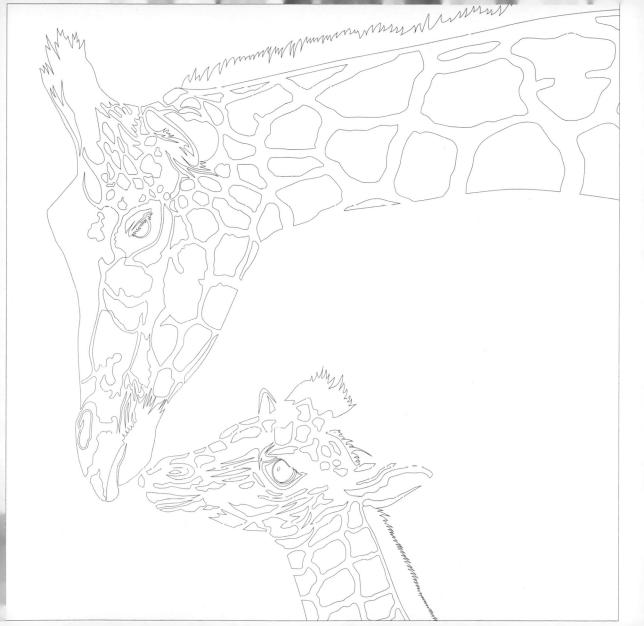

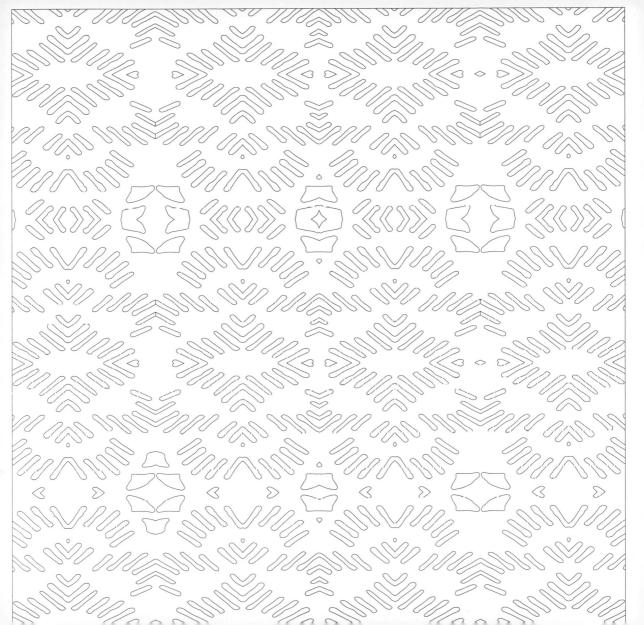

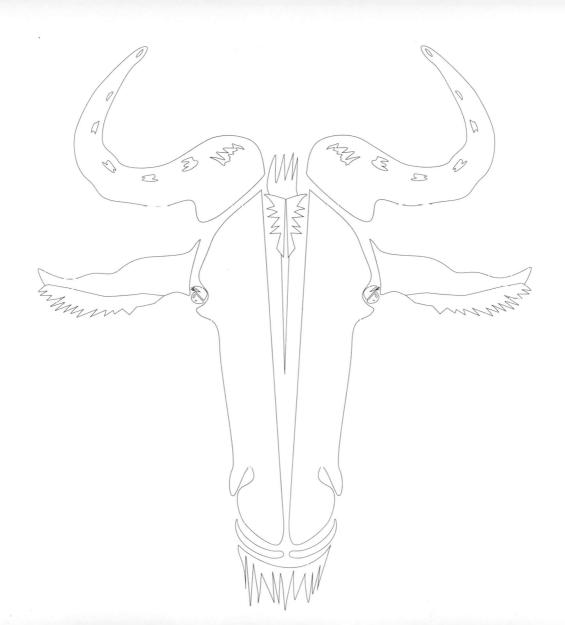

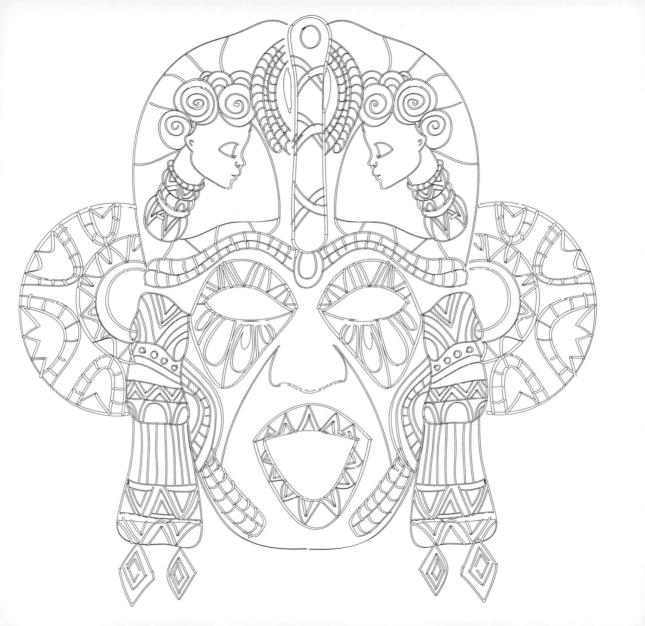

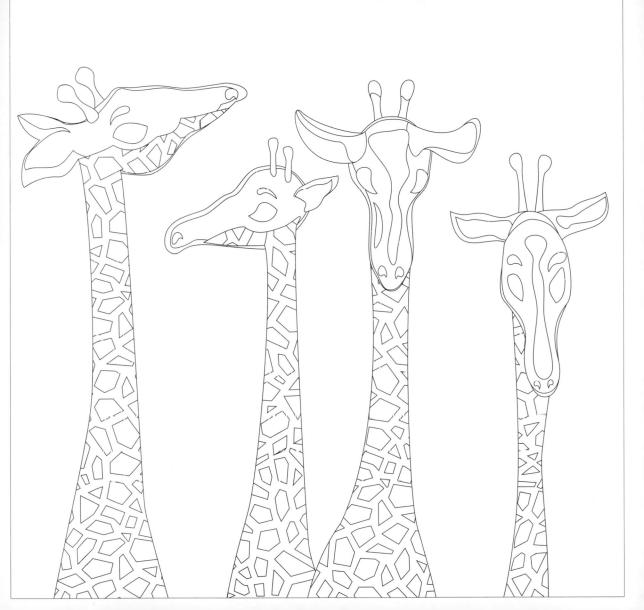

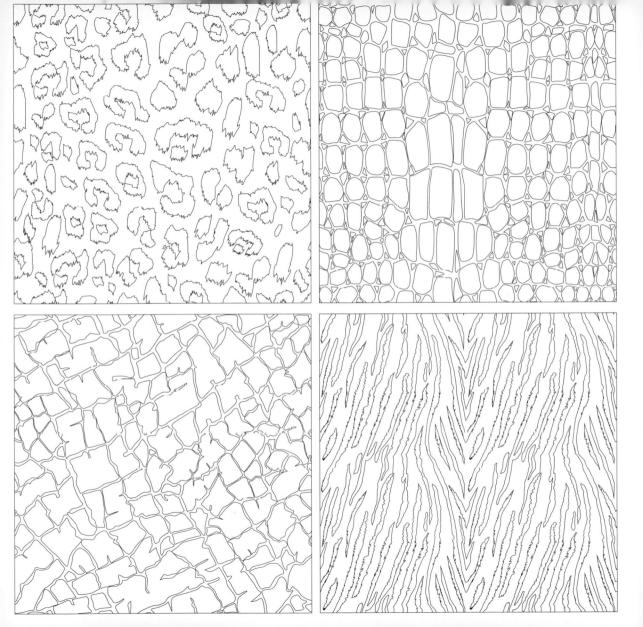

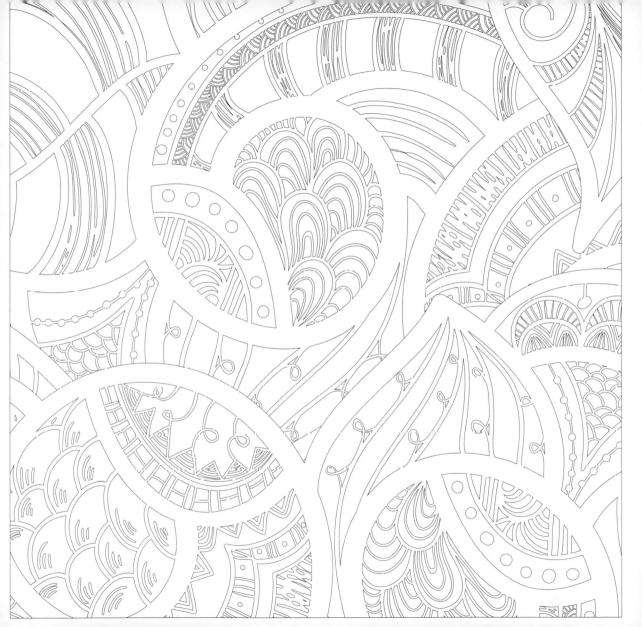

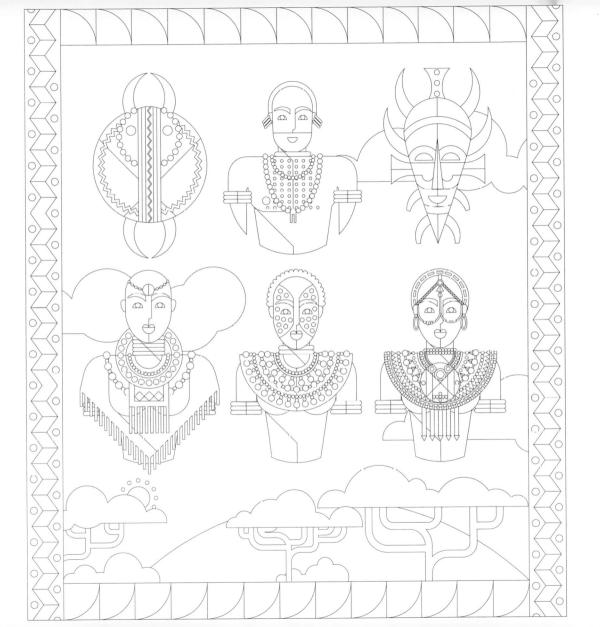

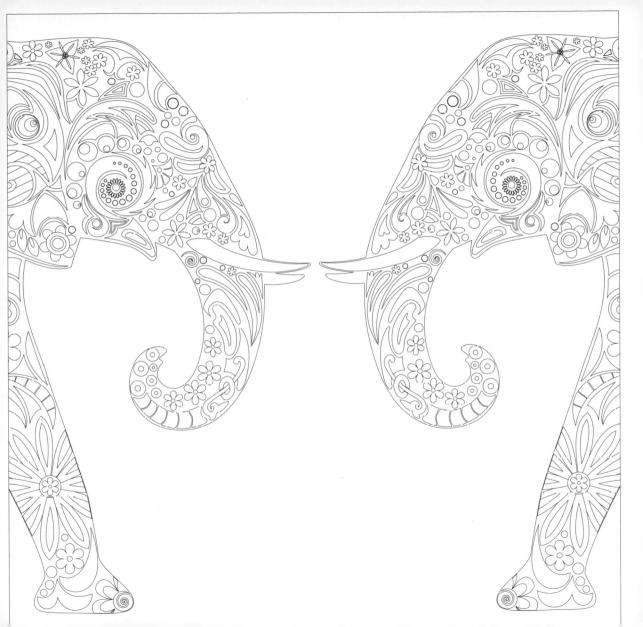

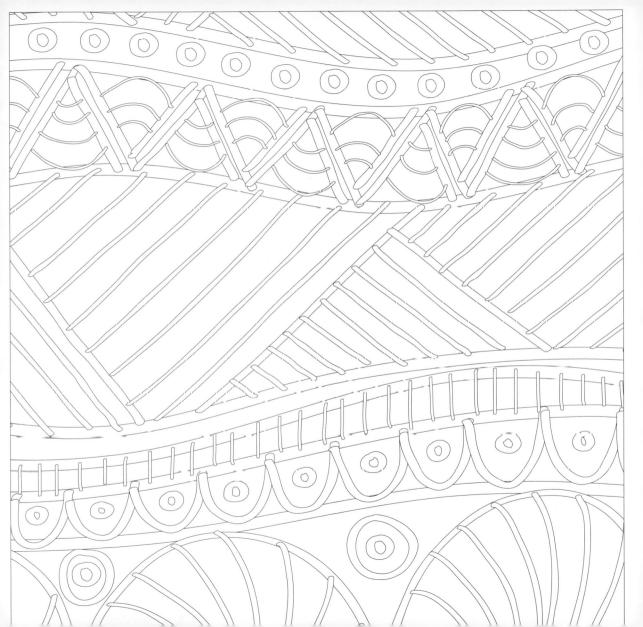

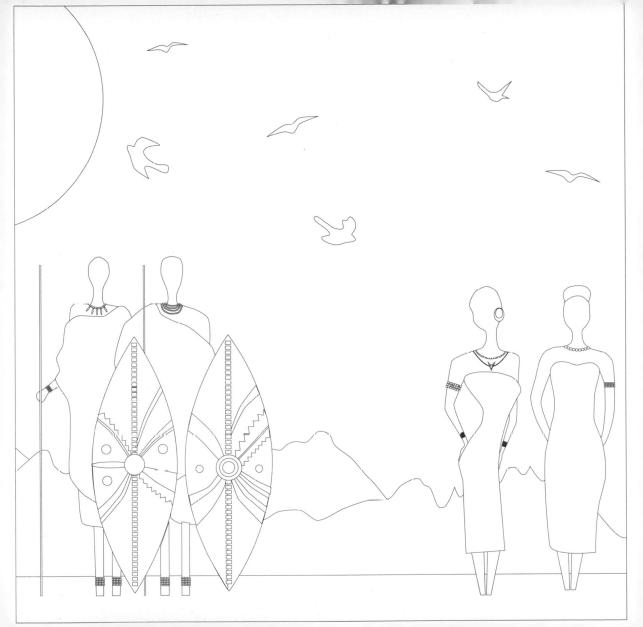

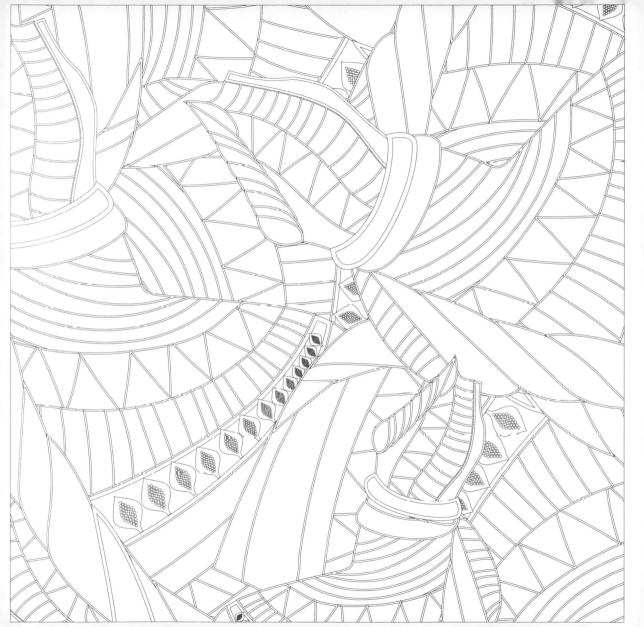

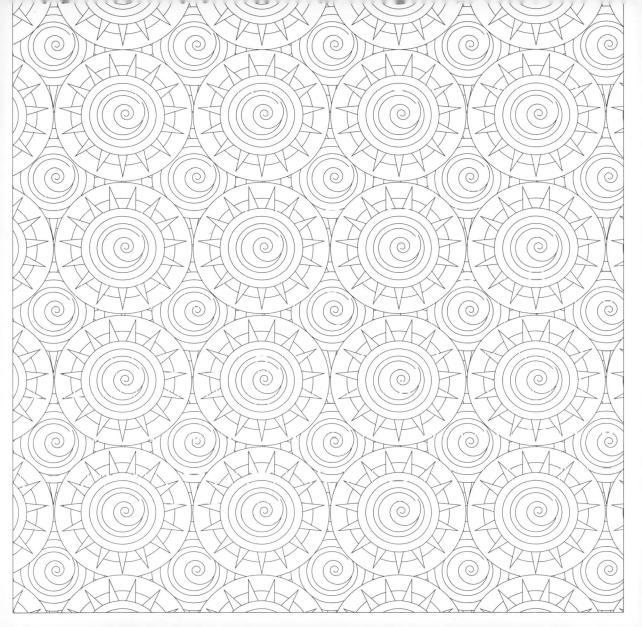

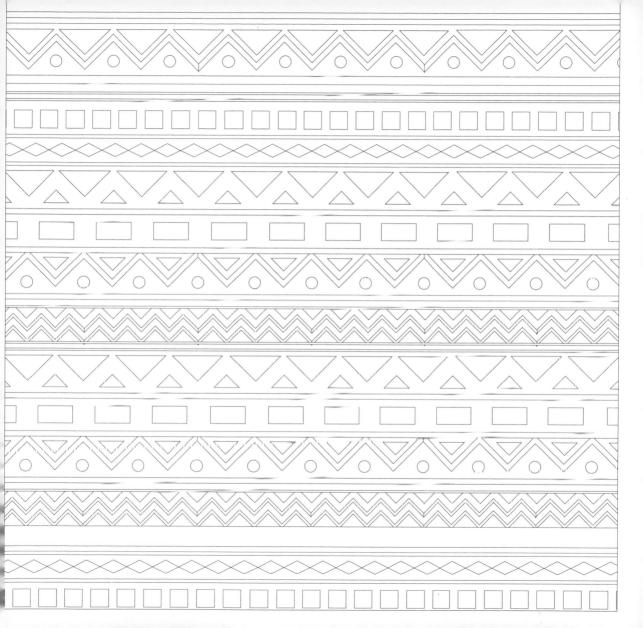

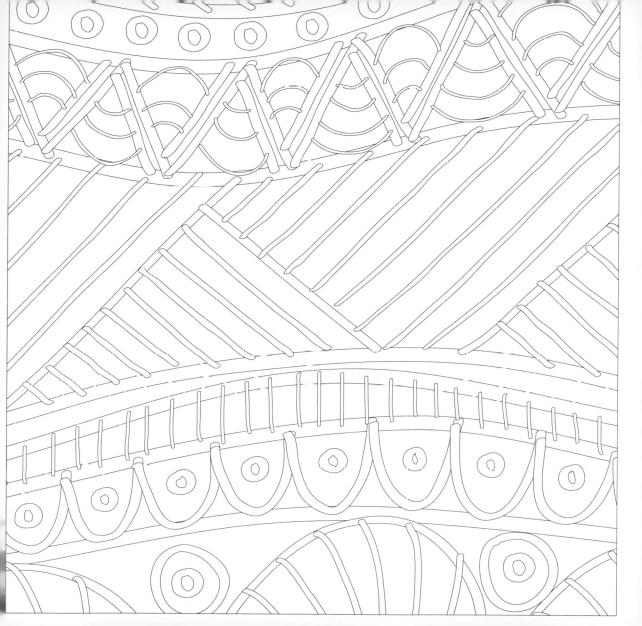

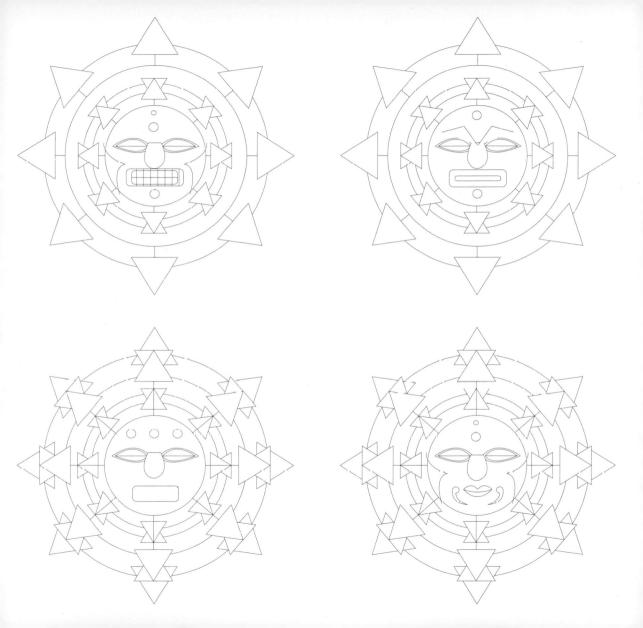

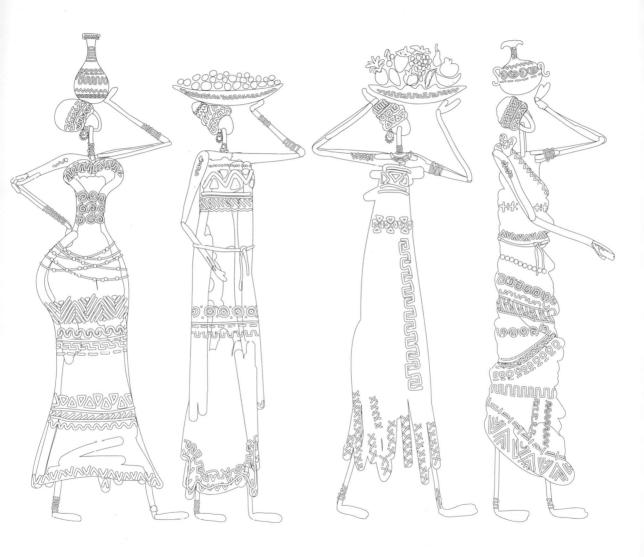

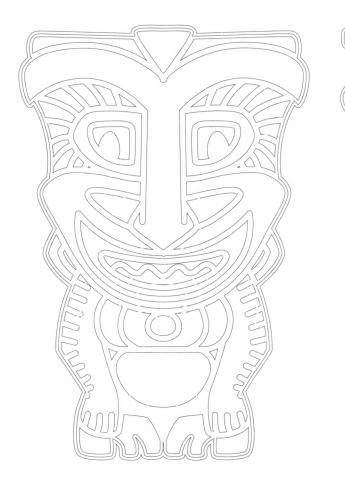

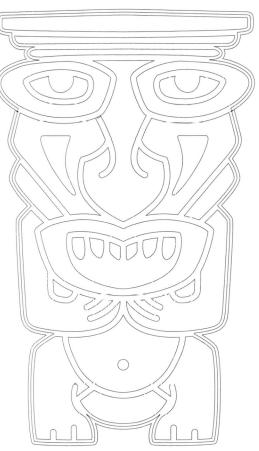

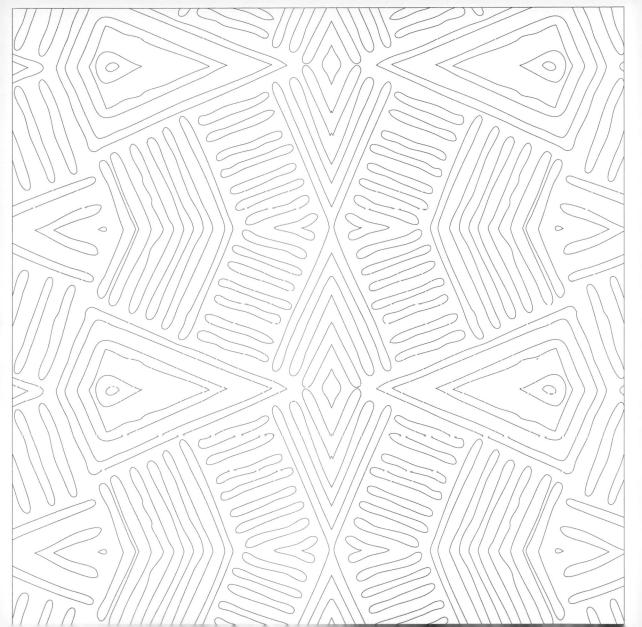

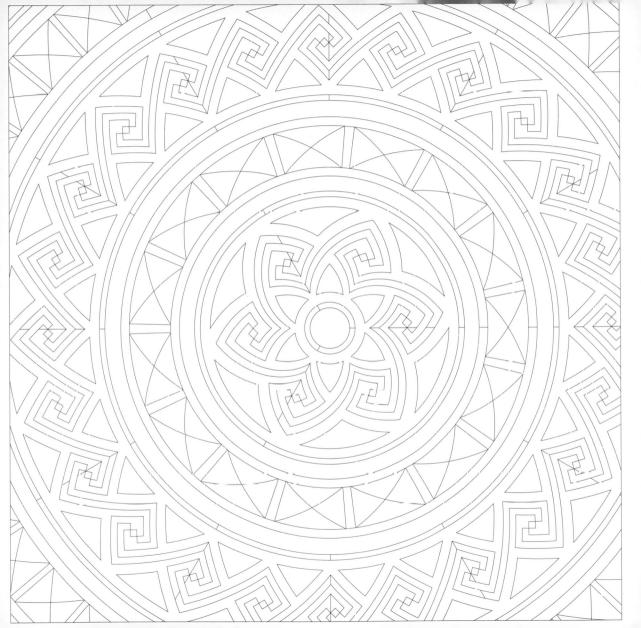

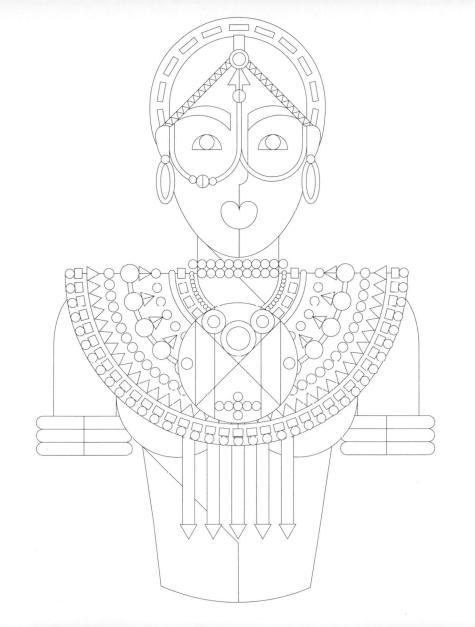

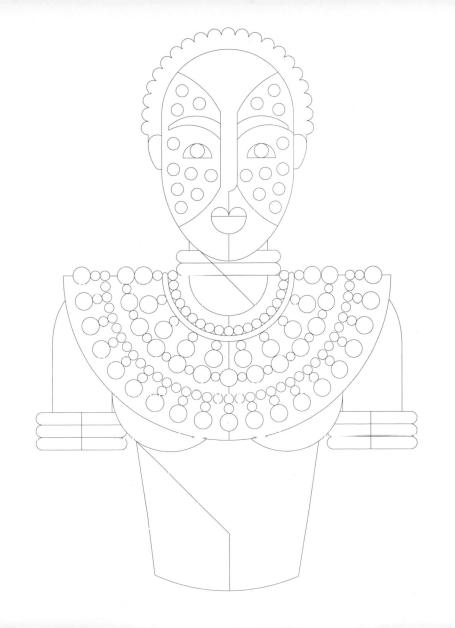

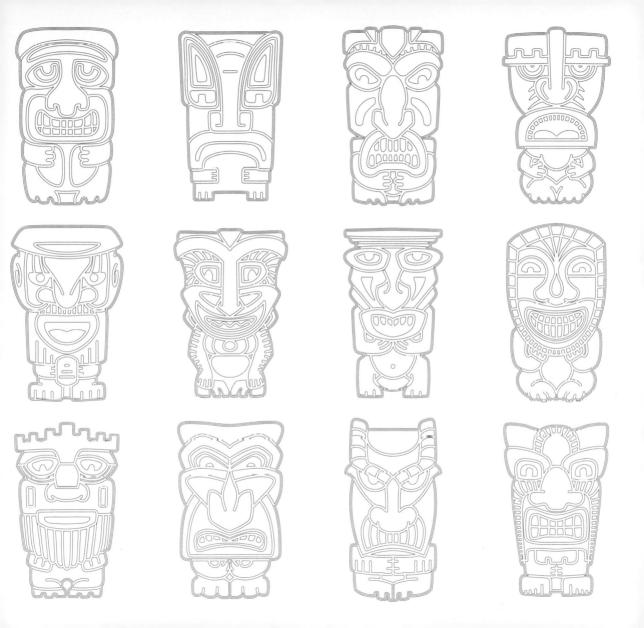

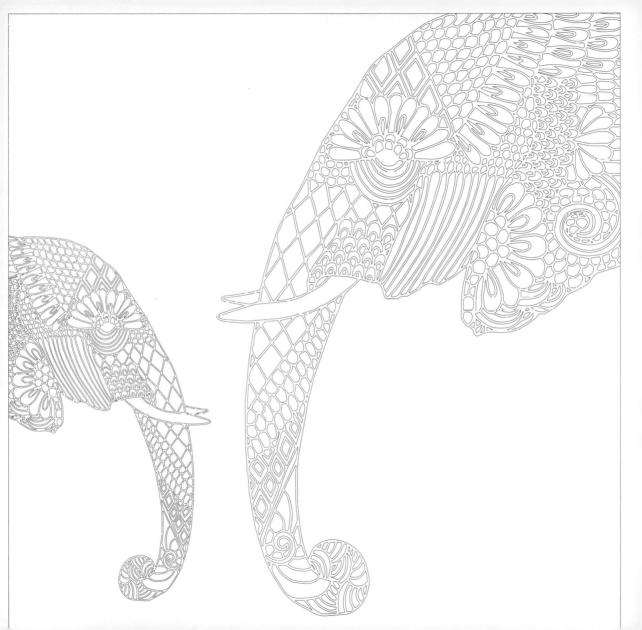

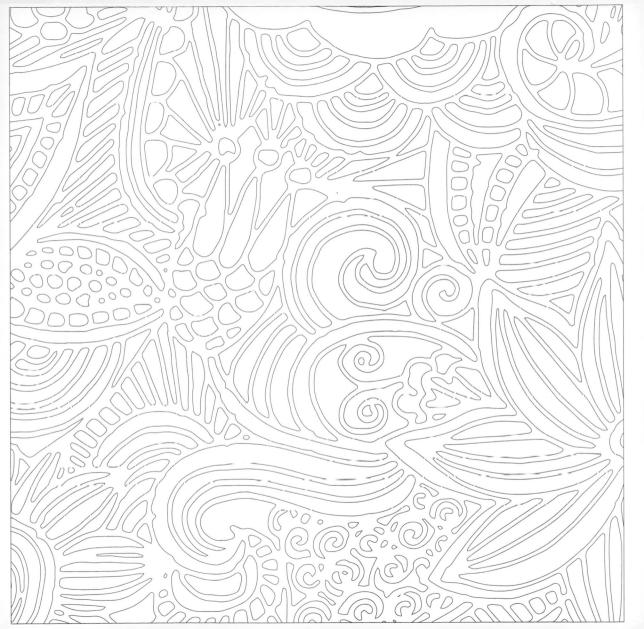

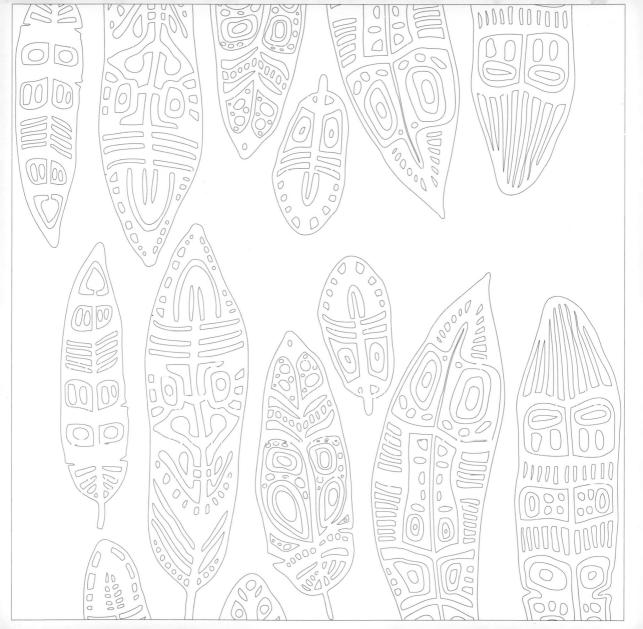

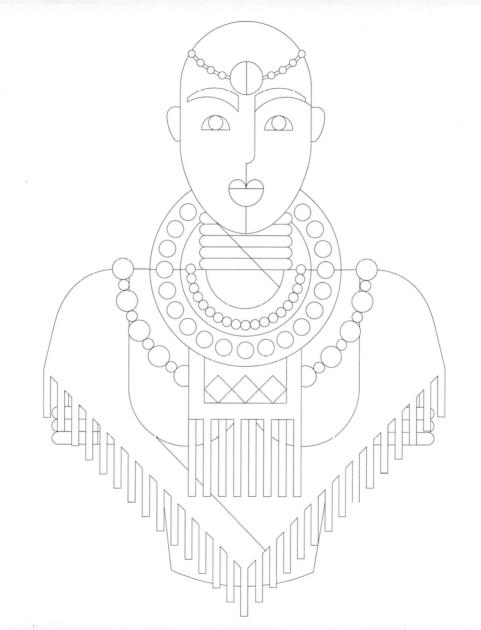